# Color Me Cherokee

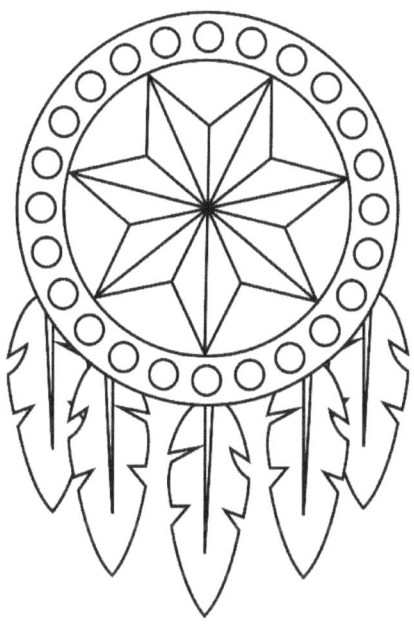

By Cherokee Artist Bryan Waytula

Copyright © Bryan Waytula 2016

All rights reserved.

ISBN: 1537778900
ISBN-13: 978-1537778907

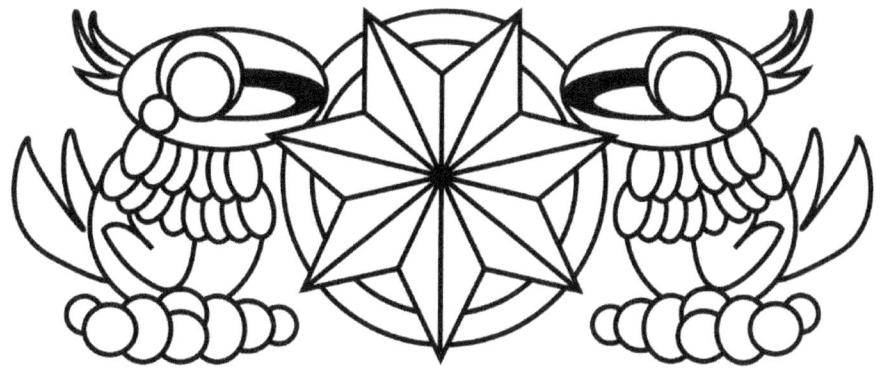

## TO ALL MY ARTISTIC FRIENDS

Osiyo! (Hello) Charles Cooley said, "An artist cannot fail; it is a success to be one." This is a quote that I'll never forget and always reiterate to all of my students I've had the pleasure of teaching. On my path to becoming a professional artist, my earliest memories are of me coloring on blank paper and in coloring books. I hope that this coloring book can be enjoyed by many people and perhaps a starting point for soon-to-be artists. Coloring books were always something that brought me, my brother & sister, friends, and family closer together. My parents nurtured our creativity and our coloring pages helped boost our creativity and self-confidence. I hope you enjoy the patterns and designs in this book that I recreated from images and memories as a citizen of the Cherokee Nation.

Bryan Waytula is a member of the Cherokee Nation and has done numerous works complimented and signed by professional athletes. He loves creating original works in pencil, charcoal, colored pencils, oil, acrylic, and ink for everyone to enjoy. Waytula hopes to continue producing his original works while teaching his students how to appreciate, respect, create and evolve their works as young artists in Tulsa, Oklahoma. Bryan grew up watching his Mother and Grandmother weave their baskets in Tahlequah, Oklahoma who now hold the honor of Master Craftsman, the highest award an artist can receive with the Cherokee Nation. "I'm extremely proud of what they've done to teach me and others of our traditions, heritage, stories, and art forms. I hope to one day leave a legacy my ancestors and family would be proud of as I strive to follow in their footsteps to leave a positive influence on the people I meet through my artwork."

# COLOR TEST PAGE

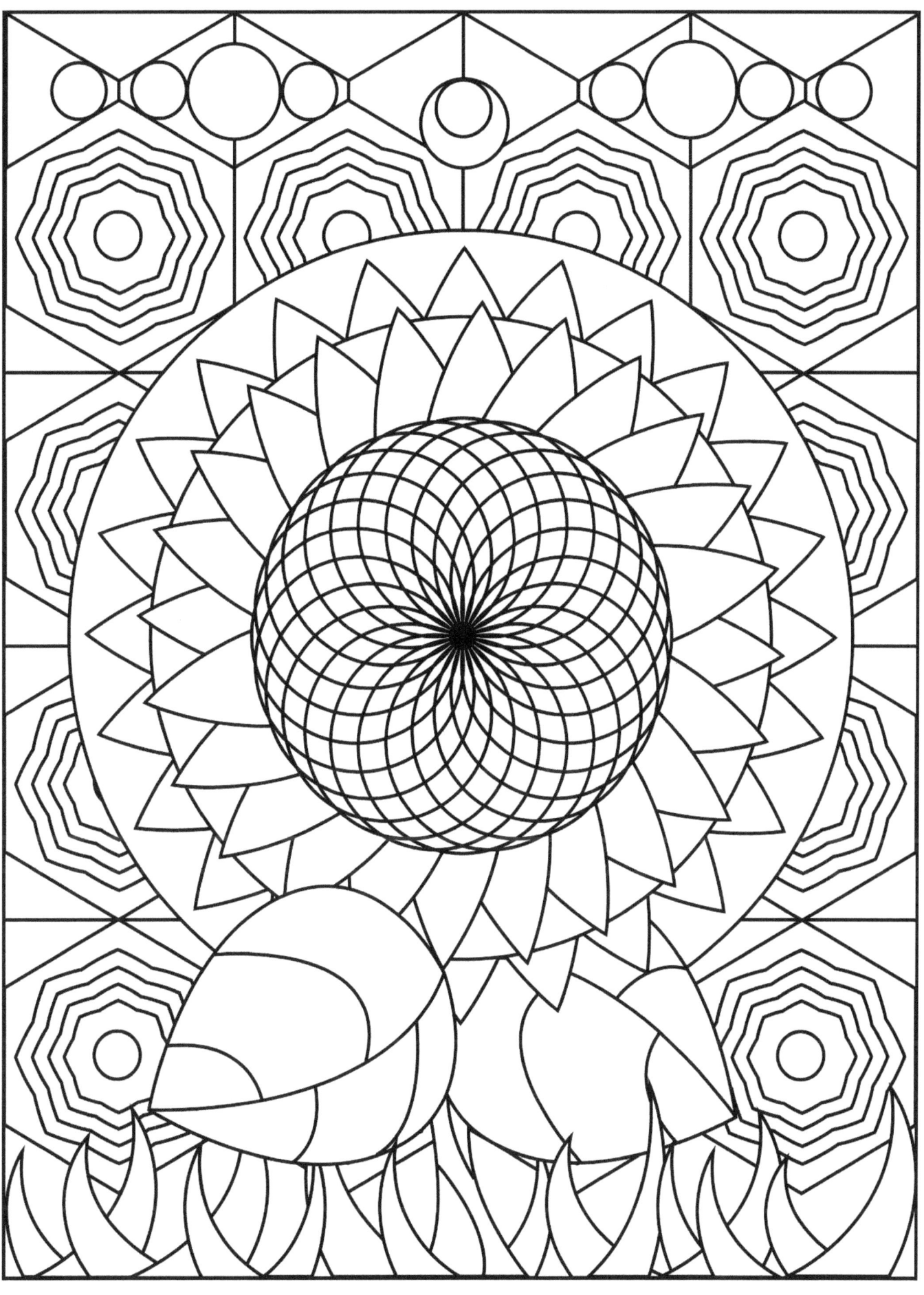

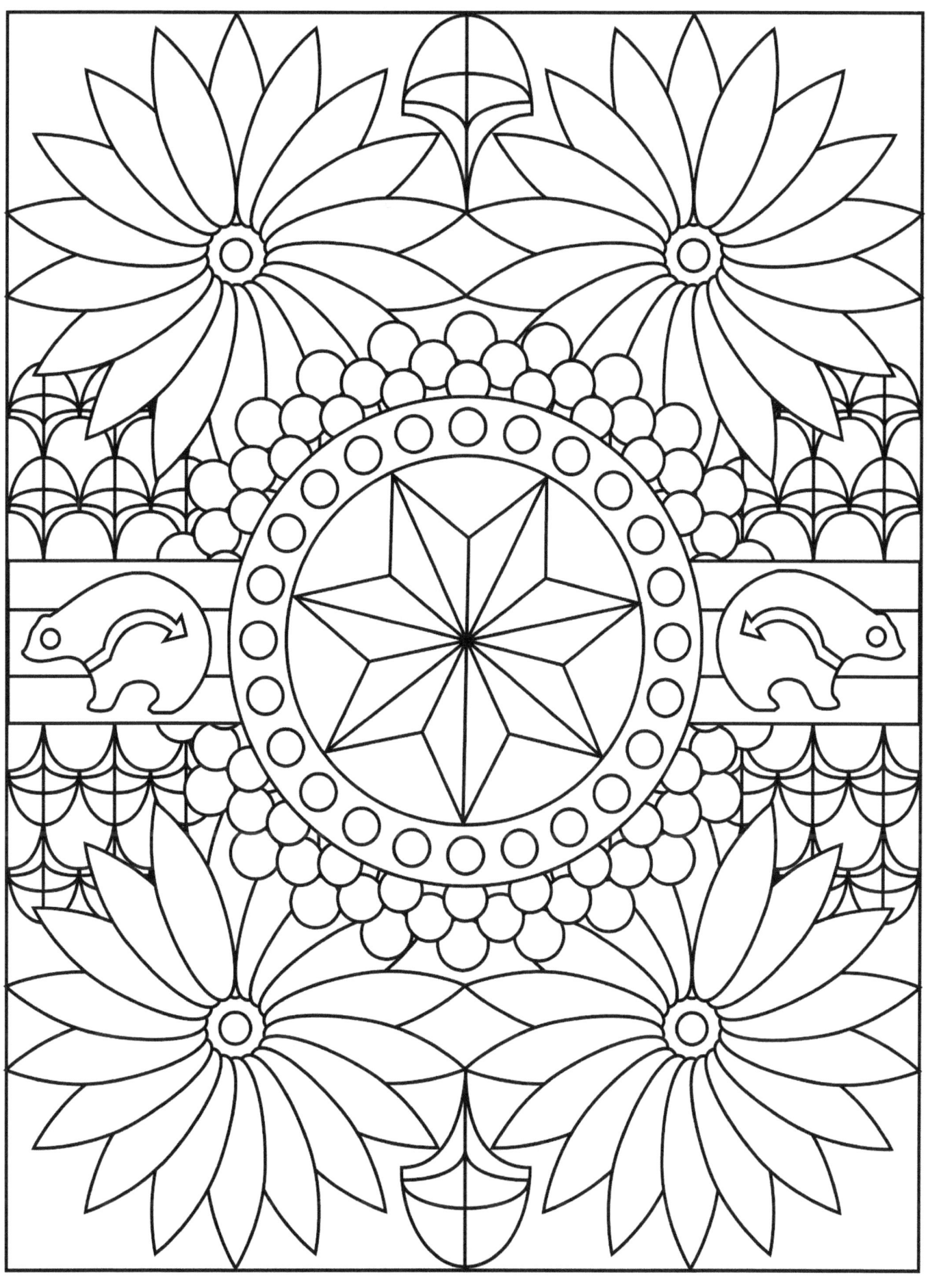

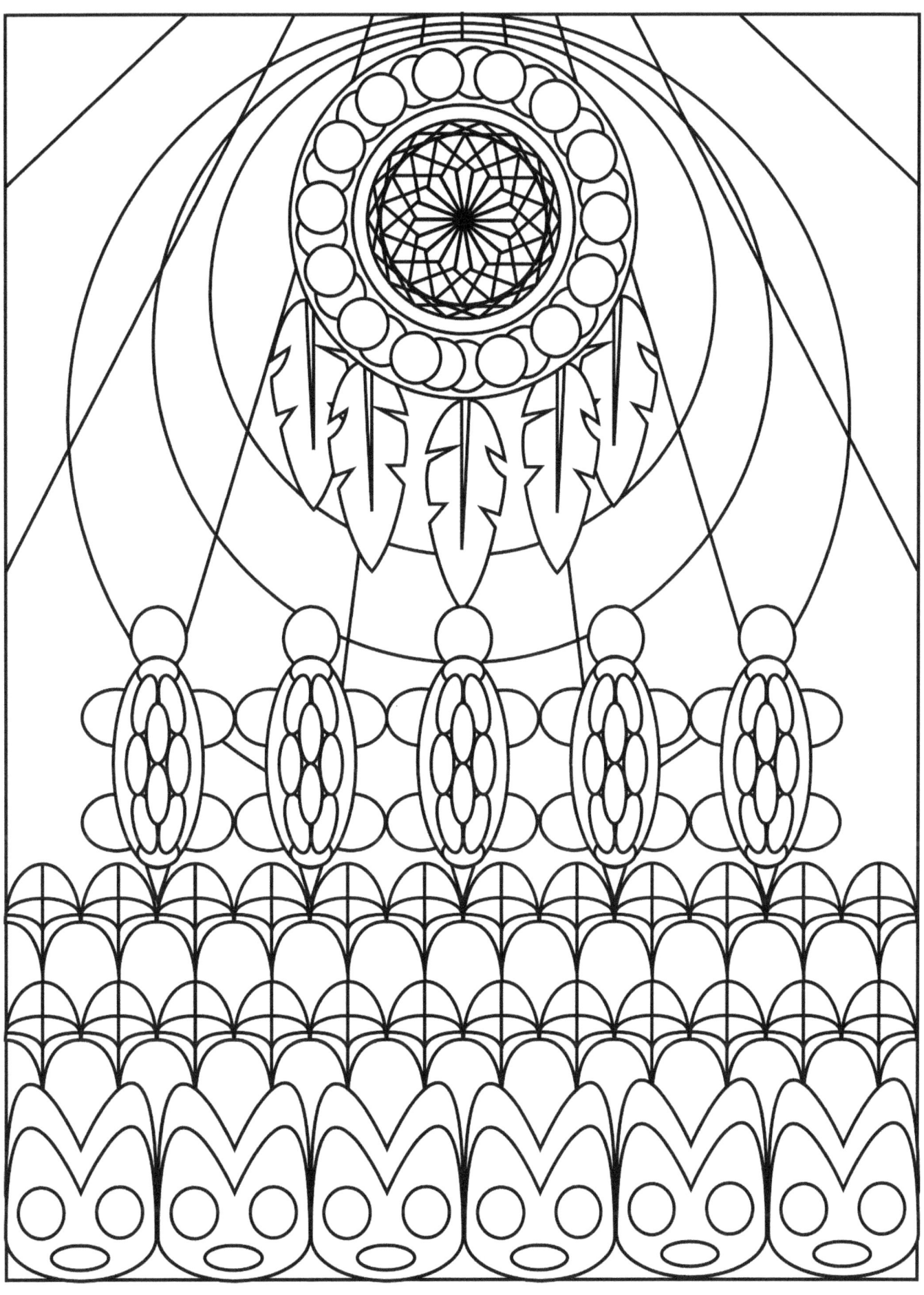

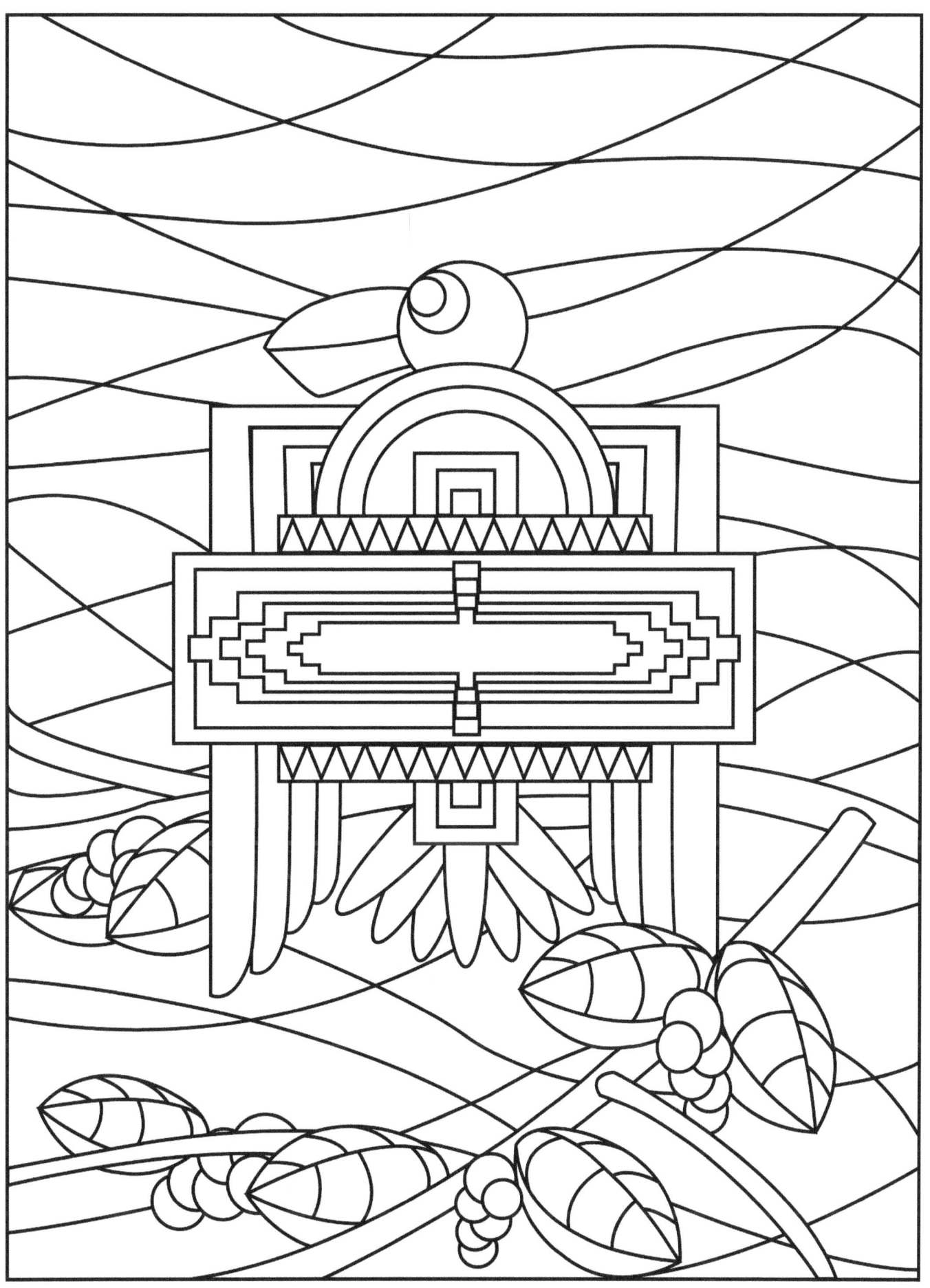

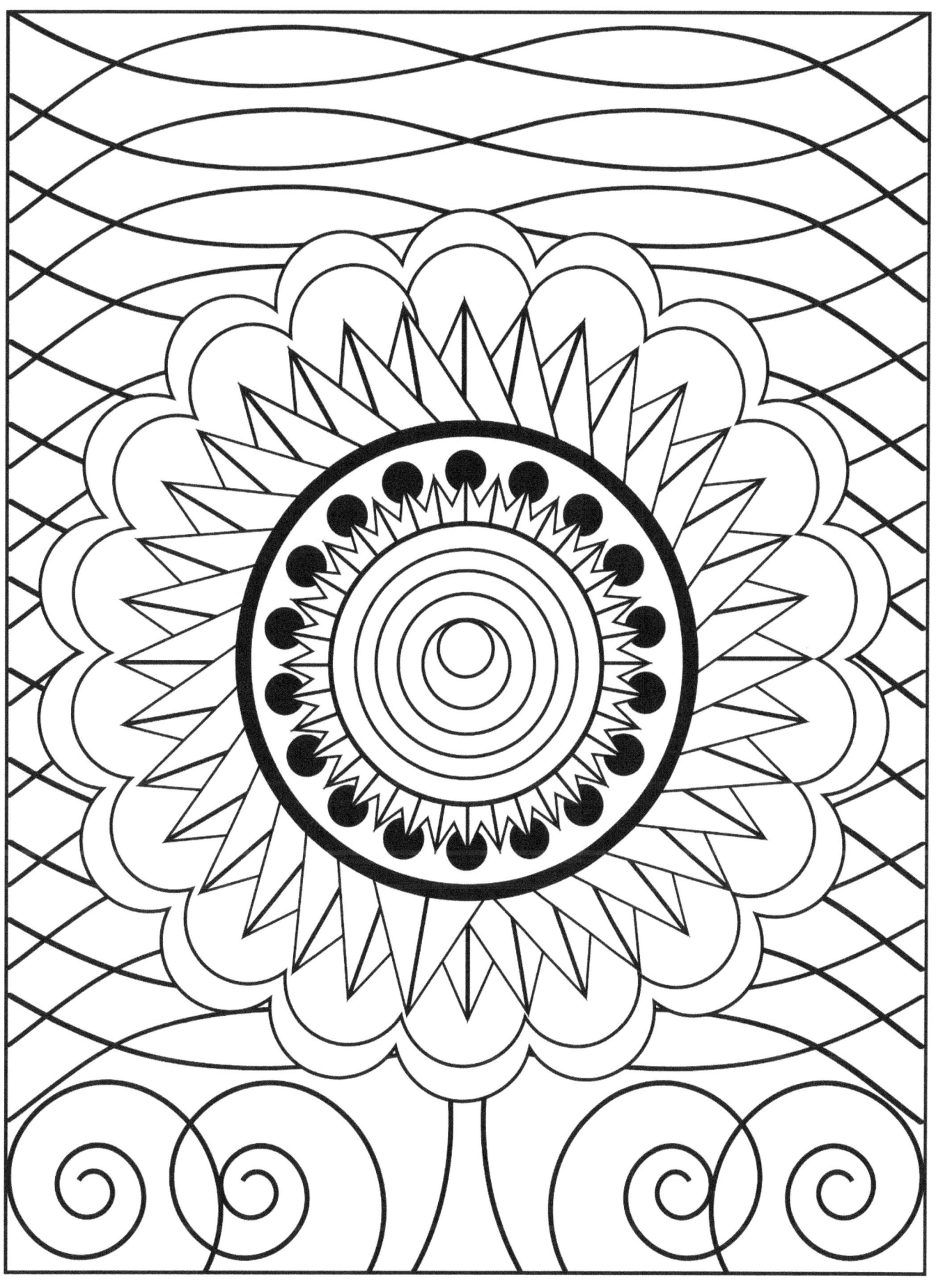

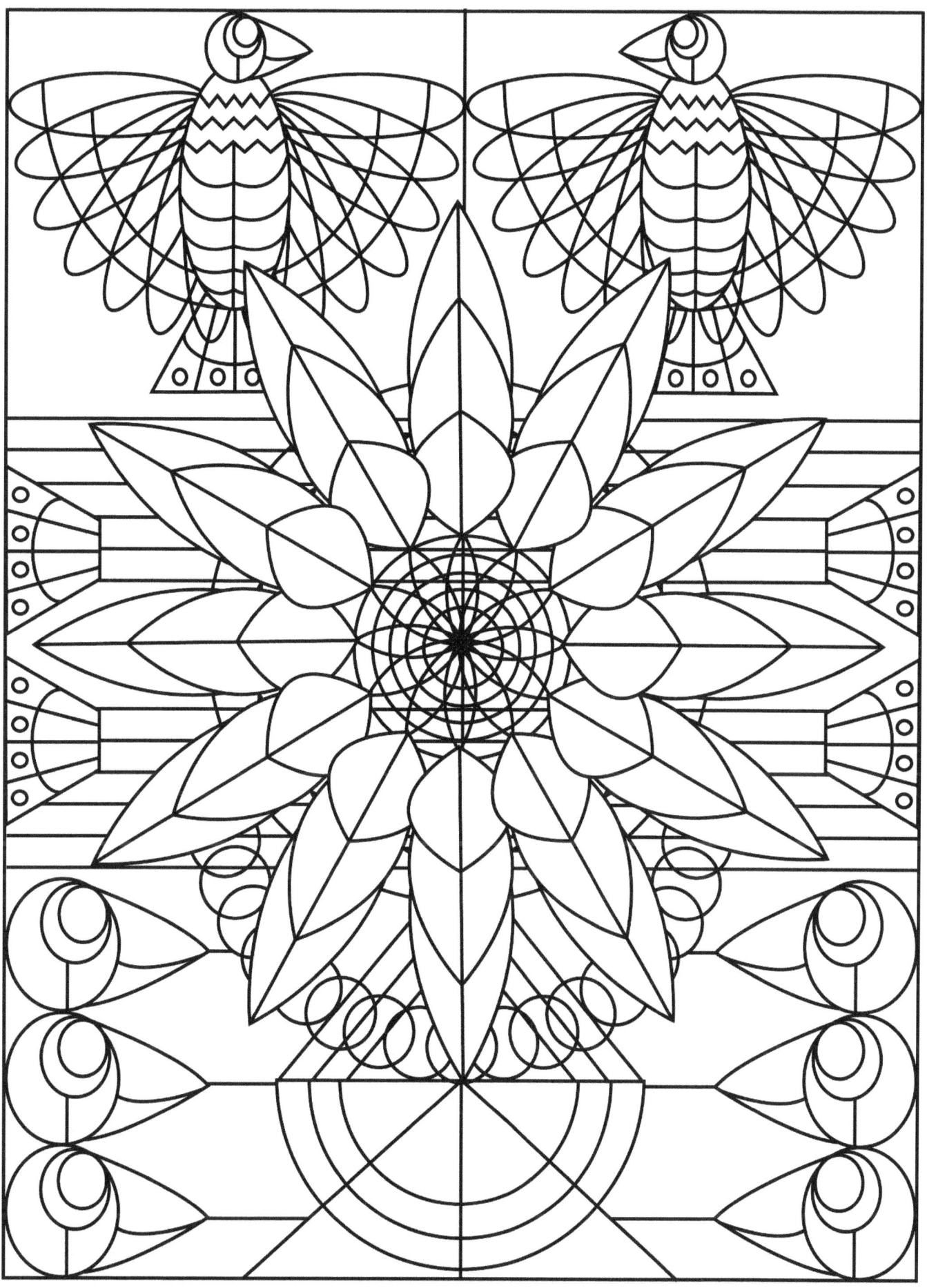

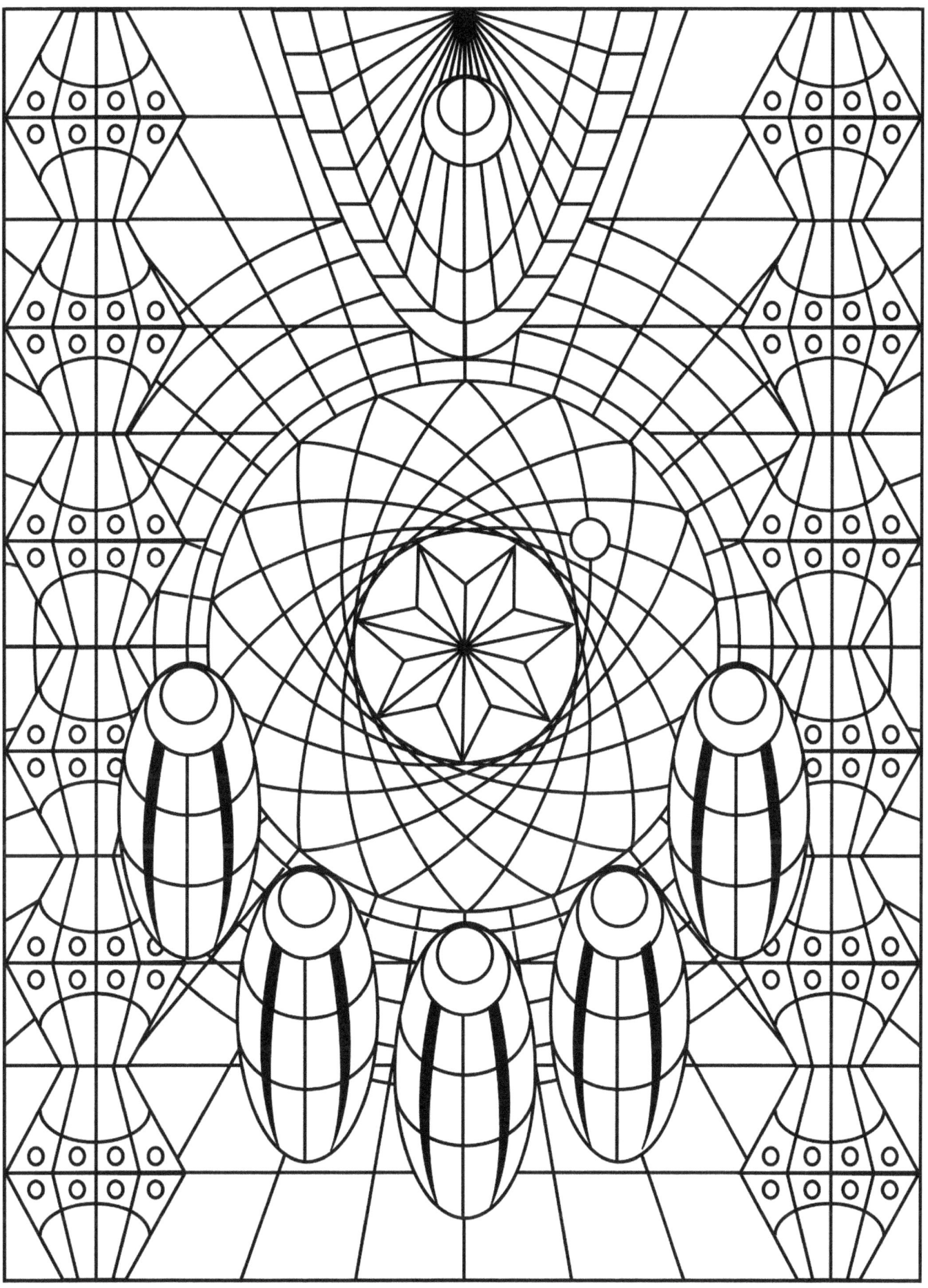

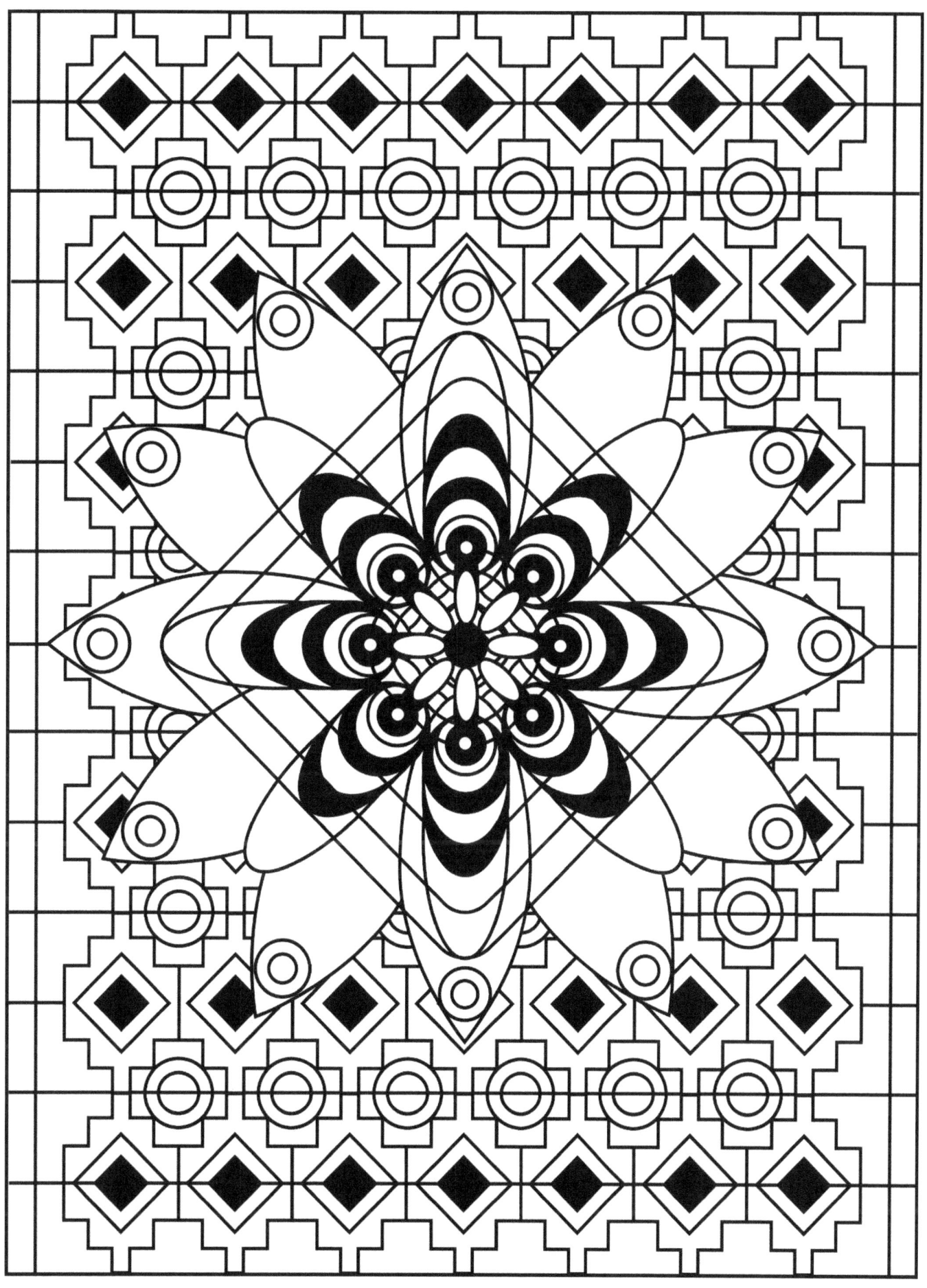

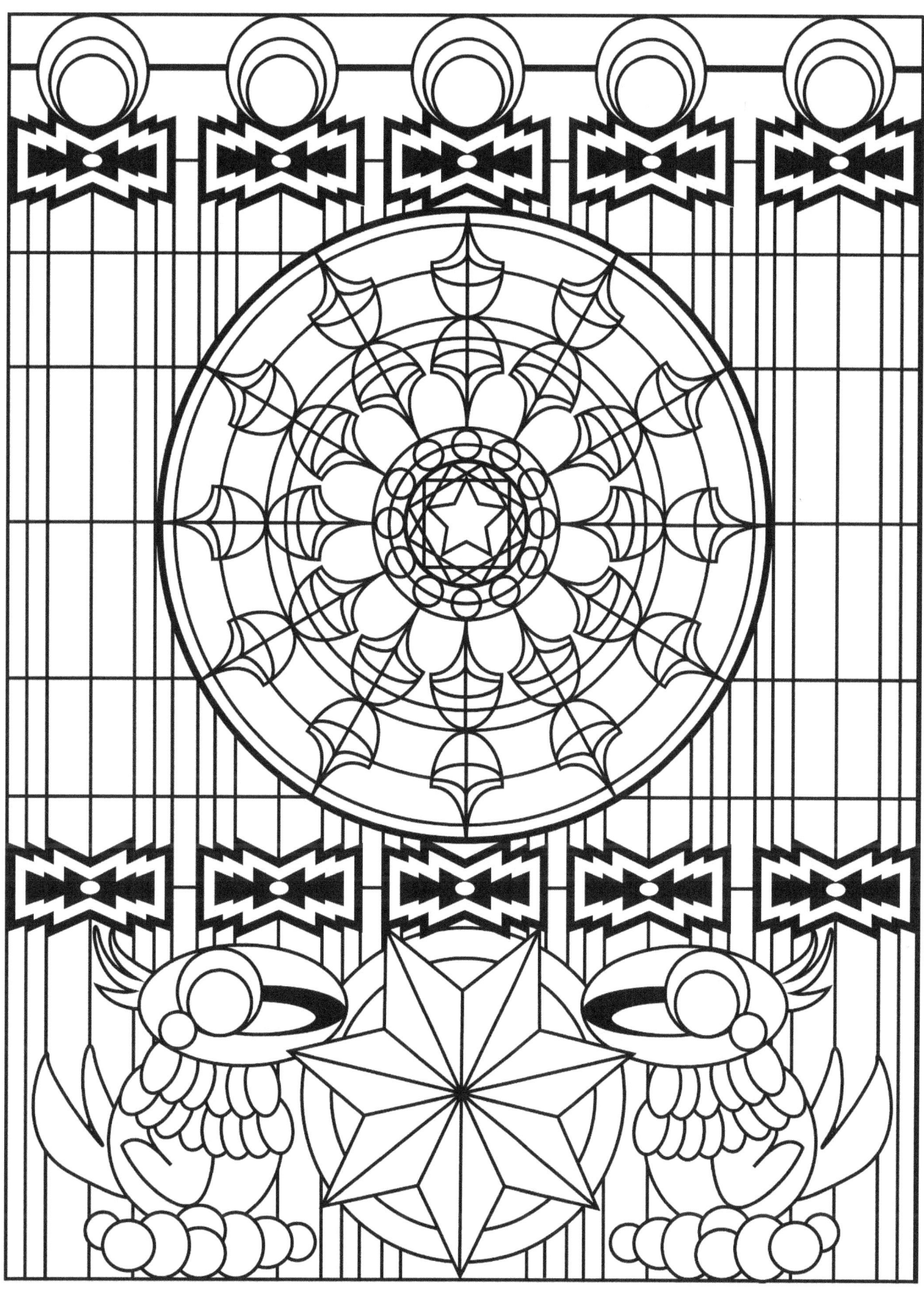

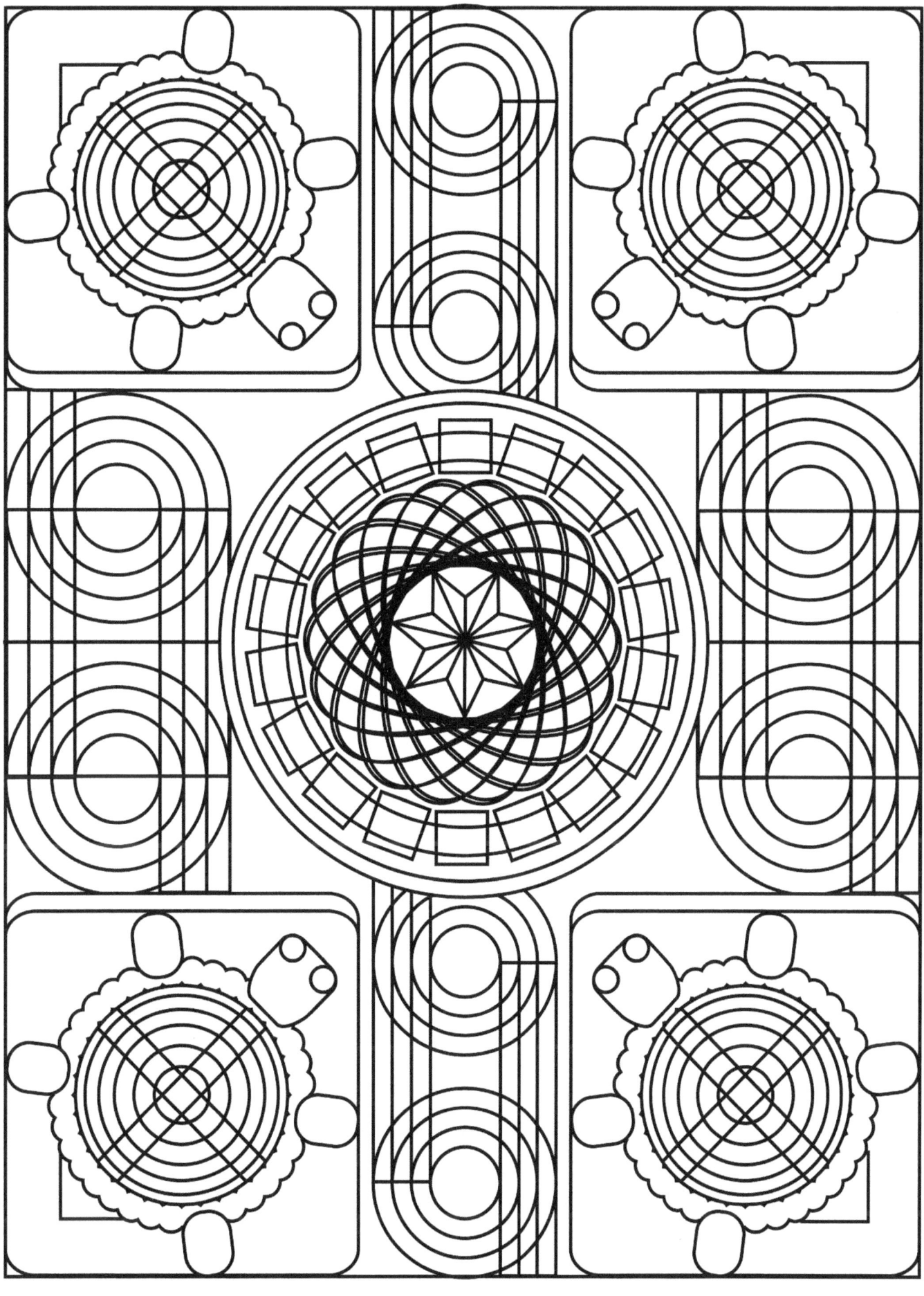

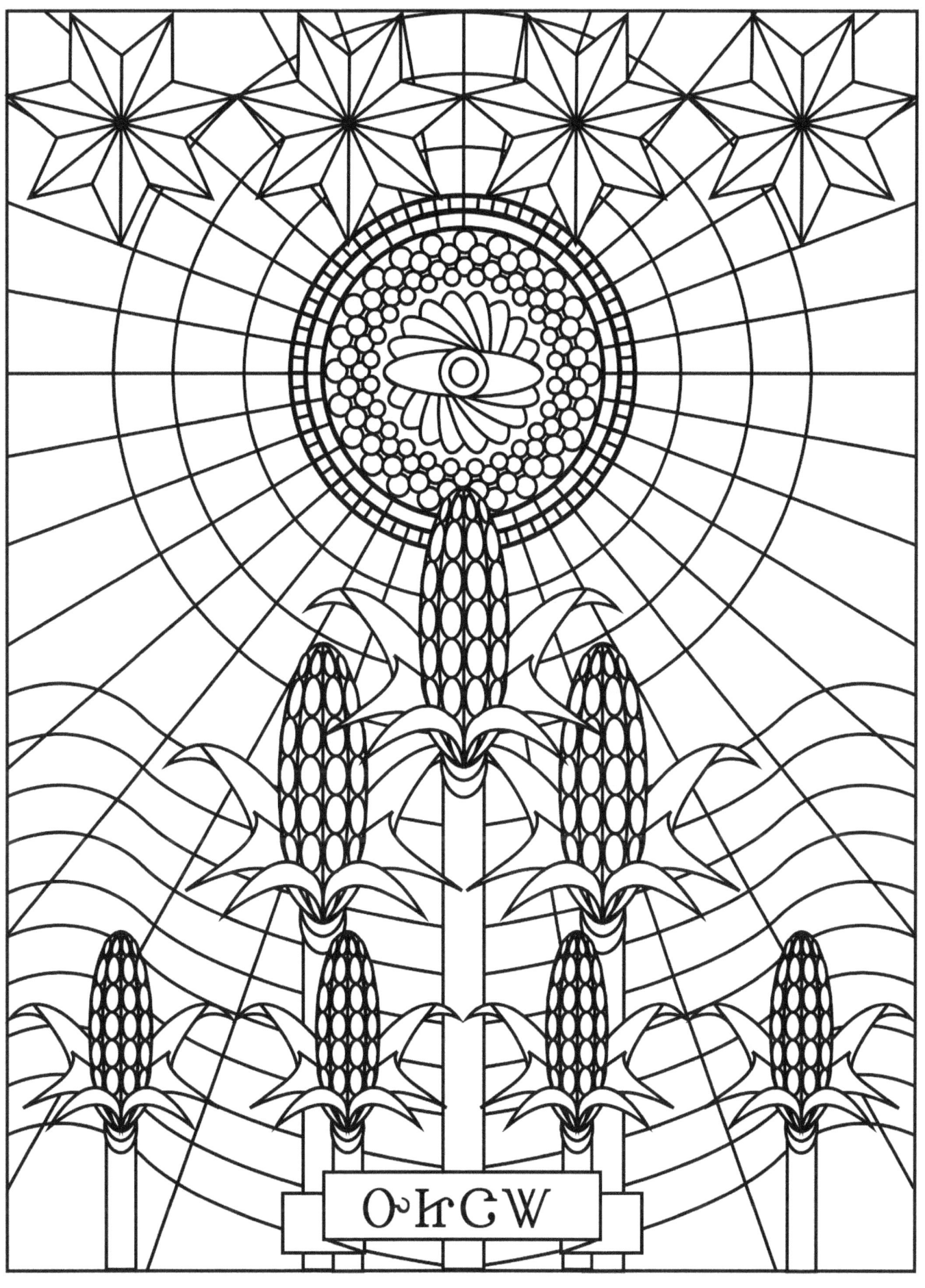

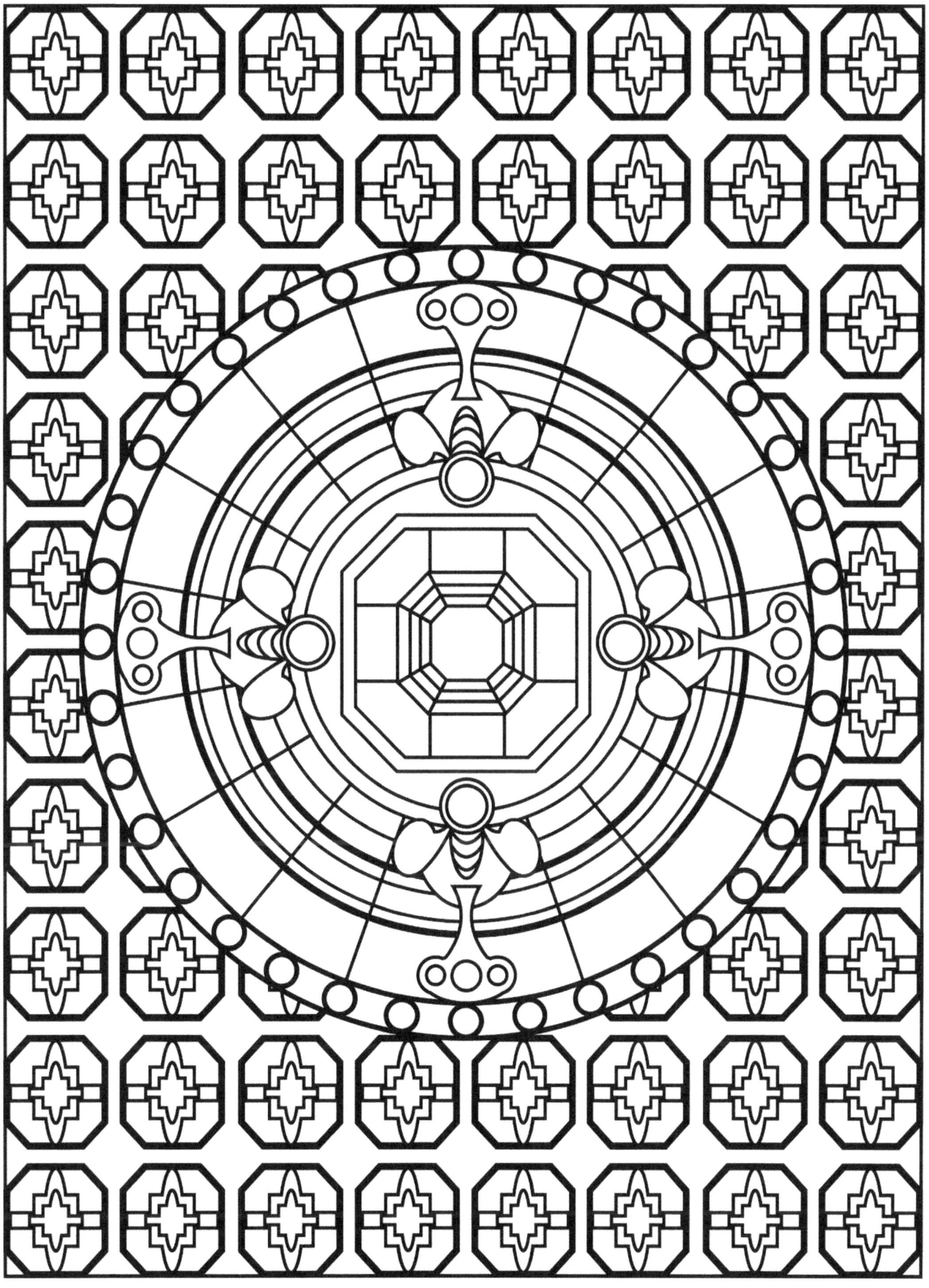

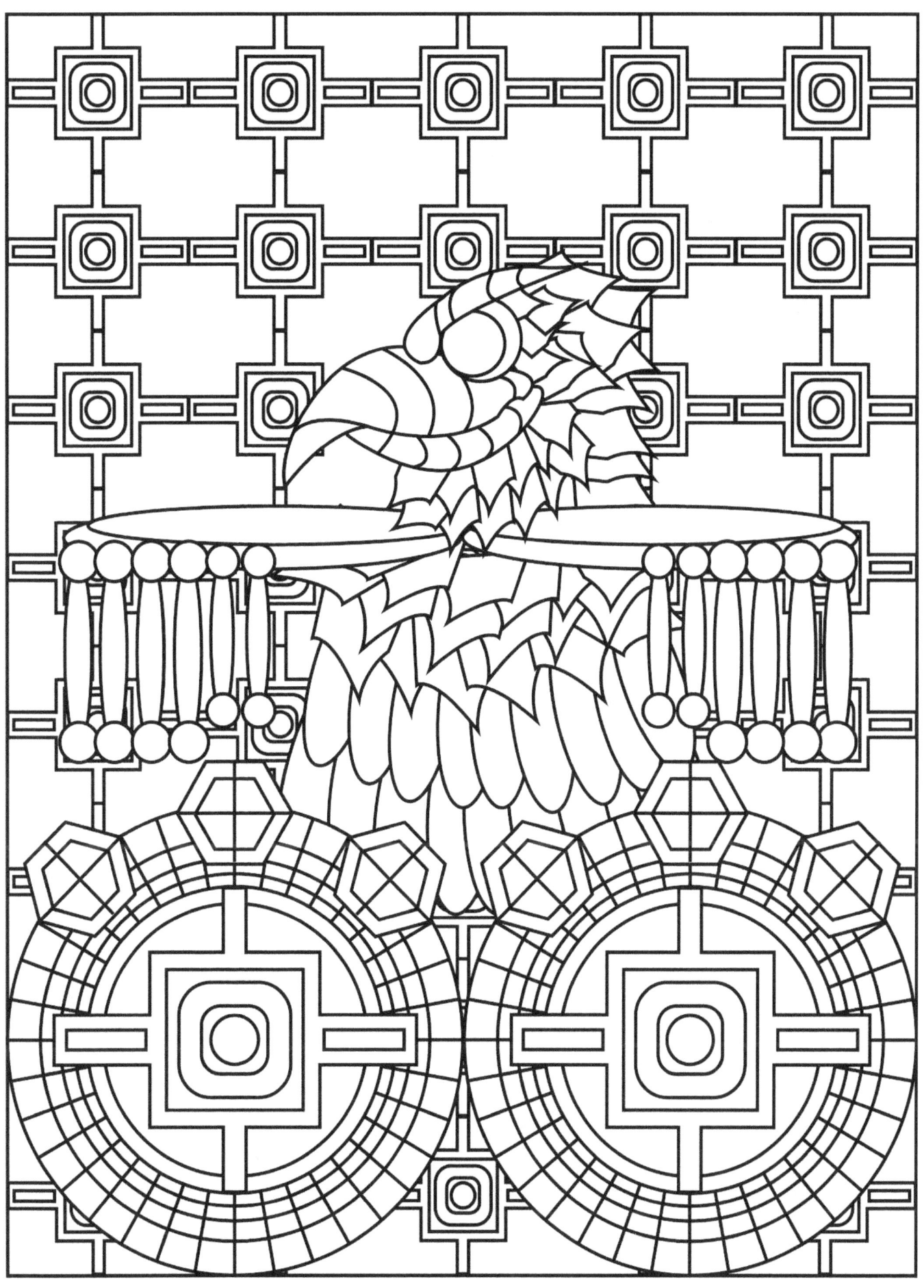

www.ingramcontent.com/pod-product-compliance
Lightning Source LLC
Chambersburg PA
CBHW080524190526
45169CB00008B/3051